TERRY FROST BLACK WHITE AND RED

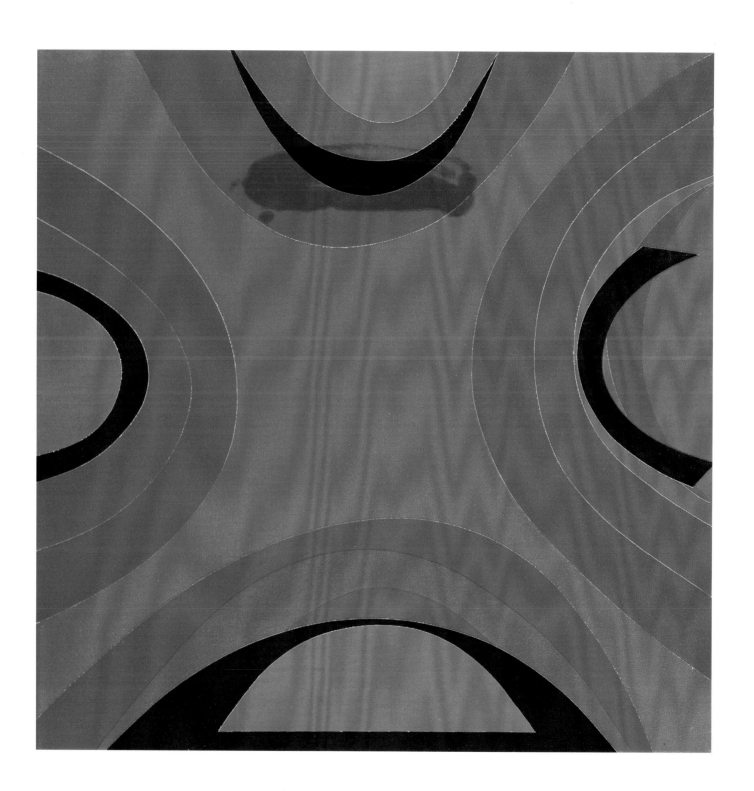

INTRODUCTION

Stepping into the studio with Terry Frost – one of many visits in the course of planning this project – my imagination is swept up in the ensuing conversation whilst Terry is showing me his latest works for our exhibition. Like a magician, he shows, one after the other, a sequence of works that number 27 – at that stage – in a dazzling display of paintings in Red, Black and White that both express his intellectual ingenuity and illustrate his lexicon of forms used throughout the past 40 years.

A sculptural dimension is included in this multi part work *Installation – Contrasts in Red Black and White* where cubes in red black and white are placed in relation to the paintings – an idea that Frost says he has wanted to realise for many years. A complete image of the piece emerges in my mind's eye and I see how Frost's discovery of El Lissitzky's lithographic poster CCCP! in 1951, and the work of Kasimir Malevich has informed this new installation. In his insightful essay Mel Gooding discusses 'the multi-dimensional *reality* of the graphic mark' and how and why Lissitzky and Malevich in particular were such an important revelation to Terry Frost.

This exhibition also includes a display of important paintings made between 1954–1956 when he took up the post of Gregory Fellow at Leeds University. This was a key moment in Frost's development when he was moving towards the most rigorous realisations in his painting of the fundamental principles of his own art. This publication however, primarily illustrates and contextualises the new and extraordinary presentation devised and executed by Terry Frost for Tate St Ives entitled *Installation – Contrasts in Red Black and White* 2002/03.

I am grateful to many people for their generous participation in this project in particular, I must thank the lenders to the exhibition; Charles Booth-Clibborn, Ronnie Duncan, David and Hilda Manson, Jeremy Ludlam, Jill Constantine of the Arts Council Collection,

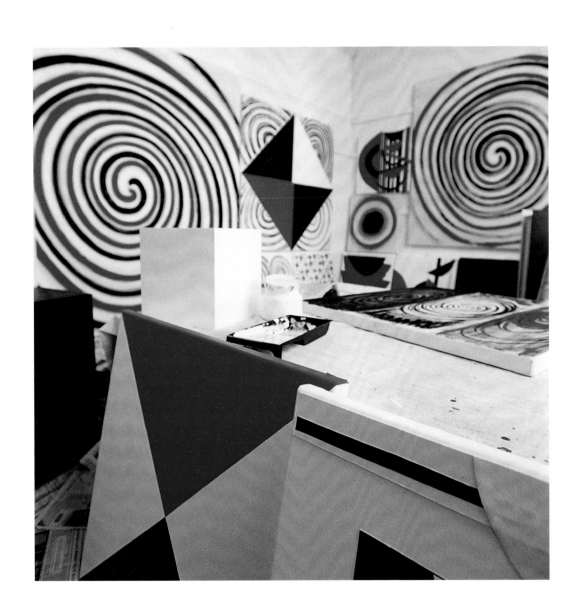

Diana Eccles of the British Council, Corinne Miller of Leeds City Art Gallery, Peter Adie, Peter Klimt, Professor J Harris, T L Johnson and the Heath family.

Several Tate colleagues have provided invaluable preparatory assistance to us; Registrar Kate Parsons for complex and helpful transport arrangements, Conservator Mary Bustin worked on the Leeds paintings prior to their arrival in St Ives and Curator Matthew Gale helped to edit this catalogue. Thanks also to Andrew Dalton, until recently Curatorial Officer at Tate St Ives, who has contributed an essay to the broadsheet which accompanies Terry Frost's Leeds paintings. Thanks also to Rex O'Dell who completed the 31' wall painting for this exhibition on Terry's behalf.

Our warm thanks to Kath Frost who always seemed to be supporting us with welcoming hospitality and to Alexis Mayle, Terry's assistant, for managing all the administrative detail so deftly. I must also thank Sir Alan Bowness for his help and involvement with this exhibition and particularly for talking about Terry Frost and his life at the opening reception.

We are deeply indebted to Mel Gooding whose eloquence in his writings about the detail of Frost's professional history and the development of his paintings, pinpoints the ideas and artist's precisely intelligent comprehension of the exciting potentiality of abstraction.

Lastly, we owe Terry Frost a great deal for his tremendous sense of fun, his generosity of spirit, his continuing support of Tate St Ives and his close involvement and passionate commitment to this exhibition.

SUSAN DANIEL-McELROY
DIRECTOR, TATE ST IVES

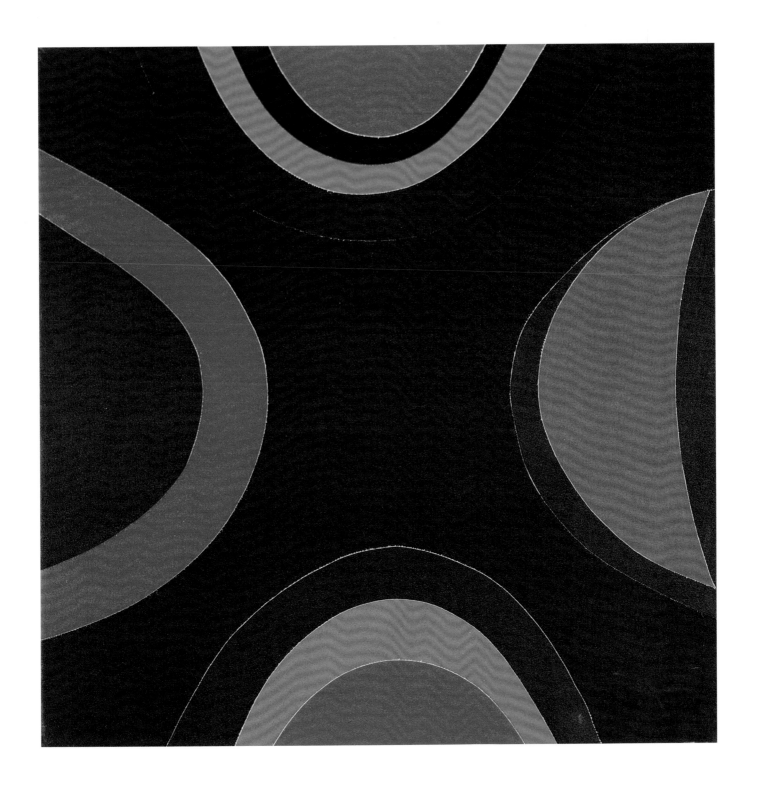

TERRY FROST BLACK WHITE AND RED

THIS ESSAY IS FOR KATH FROST

The extraordinary presentation devised and executed by Terry Frost for Tate St Ives has been described by the artist as 'an installation around an idea'. It is an idea that has possessed the artist for many years. And it is greatly appropriate that he should have found the opportunity for its realisation in the modern space of a gallery whose geographical siting is purposefully linked to a history of artistic effort that has been marked, in certain crucial aspects, by a vibrant consciousness of the great modernisms of cubism, abstraction and constructivism. For the idea, which is affectingly uncomplicated and yet not without complex implications (though they are neither critical nor discursive, and certainly not ironic or reflexive), has its origins in Frost's precisely intelligent and uniquely direct comprehension of the meaning and potentiality of abstraction.

Frost has been associated with St Ives since the very beginning of his professional career and was personally close, in the most intense and fruitful way, with many of the most significant artists who lived and worked in the locality in the post-war era. 'St Ives', the term, signifies a locus of creative *activity*, a place where people lived (they came to West Penwith for various reasons or as a consequence of differing personal circumstances) and worked (in what now seems an astonishing concentration of high talent diversely exercised). It was not, for all the lively discussion and argument that took place in pubs and over kitchen tables, a centre of theory. There was, nevertheless, a keen awareness of the stylistic and theoretical currents flowing through the *avant-garde* centres of Paris and, later, New York. It was an awareness tempered, in most individual cases nevertheless, by a healthy and tough-minded resistance to international fashion, and a general disinclination among the artists concerned to publish high-flown statements of general philosophical principle or to form groups and issue manifestos.

Frost's writing (in letters and occasional notes, always informal, rarely for publication), like his speech, combines an emphatic colloquialism with a poetic grace, and is almost always down-to-earth and specific. His contemporary, and the most significant critical voice in 'St Ives', Patrick Heron, was among the very best art critics in post-war Britain, whose greatest strength

consisted in his painter's eye, the ability to look at painting *as such*, and to convey in words a brilliantly sharp apprehension of its essential visual qualities of design, colour and texture. Heron's was practical criticism of the highest order, inflected by a lyrical enthusiasm. These native qualities of factual directness imbued with strong feeling may have been reinforced in both Frost and Heron by the examples, in disposition and manner, of those St Ives parent-figures, Ben Nicholson and Barbara Hepworth, who were influential in different ways and to different degrees upon both of them.

They are qualities that might be defined as typically English. Having the stamp of the empirical, they suggest a wariness of the universalistic philosophising and metaphysical asseveration that was so much an aspect of the claims made for their art by the first generation of great European abstractionists such as Kasimir Malevich, Wassily Kandinsky and Piet Mondrian. Neither did the language of those English post-war abstractionists associated with St Ives, who became know as 'the middle generation' (Paul Feiler, Frost, Heron, Roger Hilton, William Scott and Bryan Wynter among the most significant of them), emulate the self-dramatising 'existentialist' utterance of the contemporaneous European proponents of *art informel* and *tachisme* nor the extreme individual-istic rhetoric of the American Abstract Expressionists. Rather it reflected earthbound preoccupa-tions with the space, light and weather of the natural world, and our daily and nightly experience of it. It registered a phenomenological response to elemental realities that were not in short supply in West Penwith.

'In St Ives', wrote Lawrence Alloway, mockingly, in 1954, 'they combine non-figurative theory with the practice of abstraction because the landscape is so nice nobody can quite bring themselves to leave it out of their art.' It is difficult to believe that he ever ventured to the last peninsula at the far west of Cornwall: 'nice' is no word to describe the landscape of West Penwith in winter, nor yet in the finest summer weather when its particular spare and wind-and-sea-burnished beauty is to be experienced at its most hospitable. Alloway was, of course, out to make a reputation as a critical tough-guy, and he was keen to identify with international trends against provincial (English) concerns. By 'non-figurative' he meant to denote all and any art that was not tied to the actual appearance of objects in the world, whilst 'abstraction' was subsumed under it as an art that '*drew out of* or *away from*' nature – that 'abstracted' its forms and colours from figures, landscapes and objects.

Alloway's condescension derived from the notion that a non-allusive art, made without reference to things observed but rather from some 'non-figurative' principle, was superior to 'abstraction'. The latter retained unfortunate links with what he saw as the decadence of 'the prevailing British style … a form of nature romanticism.' In short, and Alloway was not the only critic to think this, 'St Ives' lacked intellectual rigour. Of all the artists included in his little book *Nine Abstract Artists: their work and theory* (1954), Frost is the one Alloway found most 'influenced by St Ives'. But, in fact, there were other powerful influences at work in the development of Frost's ideas about the possibilities of painting that had nothing to do with landscape as romantic subject matter. They had to do, rather, with formal matters, and with the revelatory purposes of 'non-figurative' art. And they were certainly not provincial.

As a student at Camberwell, Frost had enjoyed the friendship and encouragement of Victor Pasmore, whom Alloway, as it happened, greatly admired. He visited Pasmore's studio just at the moment – mid to late 1948 – when the older artist was abandoning realism and making his earliest abstract collages and paintings. With Pasmore, Frost enjoyed some of his earliest conversations about the nature of constructive and non-figurative art, and learned, above all, that art grows out of the study of other art. 'I don't believe in this looking at nature', said Pasmore in 1948 to his Camberwell colleague William Townsend, who was dedicated as a painter to the most rigorous observation of the world and its objects. 'Looking at nature never made anyone want to paint pictures. You only want to do it and learn how to by looking at other pictures.' Frost of course saw the Redfern exhibition in November 1948 in which Pasmore showed his first post-war abstract paintings, and which featured, interestingly enough, his two earliest spiral paintings.

In the early 1950s Frost frequently stayed at Adrian Heath's Fitzroy Street studio. Heath, who was also a mentor for Frost, was working on his own small book *Abstract Art, its origins and meanings* (published, like Alloway's, by Alec Tiranti, in London, 1953). 'You'd have all these things pinned up round the kitchen', Frost recalled later, 'Kupka and all the early abstract painters, the Russian Constructivists – the whole thing was being discussed at breakfast and it was still being discussed at 2 o'clock the next morning'. These discussions, about Malevich, Mondrian, Frantisek Kupka, Naum Gabo, Raymond Duchamp-Villon and El Lissitzky among others, continuing through the early years of the decade with Heath, Anthony Hill, Kenneth and Mary Martin and others of similar creative-critical intelligence. They awakened Frost to the ideas and ideals that had animated some

of the greatest non-figurative artists of the century, though there was, in truth, little printed material on their work and there were virtually no opportunities in Britain to see original paintings. Informal as it was, it was an intense and intensive education, and it brought new dimensions of insight to an artistic intelligence that had already intuitively assimilated those aspects of cubism (mediated by Nicholson and Heath, particularly, among others) that are evident in his first major painting, *Walk Along the Quay* of 1951.

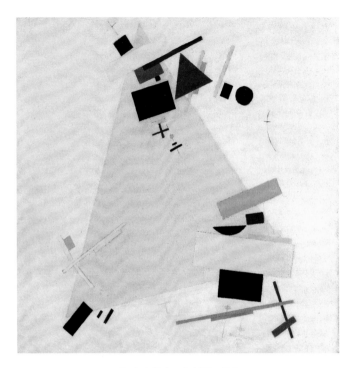

Kasimir Malevich 1878–1935
Dynamic Suprematism (1915 or 1916) oil on canvas

On one occasion, sometime in 1951 probably, though quite when it happened is unclear, Frost saw, and was amazed by, a lithographic revolutionary poster by El Lissitzky at the Leicester Galleries in London. 'Of all the lessons you can get in the world', said Frost recently, a half-century after the event, 'there's none better than seeing something that stops you in your stride, that stops your heart, and is absolutely *marvellous*!' The image (as he remembers) was in black and white with one red element, the exclamation mark at the end of the letters which constituted the principal graphic feature: *CCCP!* It was an epiphany. The simplest sign-shape repeated on a flat surface could propose dynamic movement in a space that was not that of illusionistic representation, and need not itself – the sign-shape that is – derive from any natural form. The capital C and the exclamation mark – 'a big vertical and a big dot!' – are purely formal and conventional but

disposed on the sheet in a certain way they could at once *signify* (as letters) and dynamically represent the abstract *signified* (the rush and excitement of the Revolution).

What Frost discovered at this moment was the multi-dimensional *reality* of the graphic mark. It was at once a black (or red) two-dimensional *shape* on a flat surface and a dynamically implied three-dimensional *form* in fourth-dimensional space-time. It was especially appropriate that it was through a work by Lissitzky that this revelation should have been effected, for it was Lissitzky above all who had undertaken to mediate, in graphic terms, the metaphysics of Malevich (as expressed in his paintings *and* his writings) to the broader world, and to make available to artists, designers and architects the new *constructive* insights of Suprematism. Central to this project was the notion that the new art was a means to an understanding of the new conditions of life, that art was a part of life, and that the vision of art was essentially a vision of human potentialities.

In 1920 at UNOVIS, the Vitebsk art school where he taught architecture and graphics under the leadership of Malevich, it was Lissitzky, at the high point of the Suprematist revolution in Soviet art education, who proclaimed the revolutionary moment:

> at present we are living through an unusual period in time a new cosmic creation has become reality in the world a creativity from within ourselves which pervades our consciousness. for us SUPREMATISM did not signify the recognition of an absolute form which was part of an already completed universal system. on the contrary here stood for the first time in all its purity the clear sign and plan for a definite new world never before experienced – a world which issues forth from our inner being and which is only now in the first stage of its formation. For this reason the square of Suprematism became a beacon.

Never before had art, as such, been promoted as the very means to the realisation of a new kind of consciousness, a new transcendence of experience, a new kind of *being*. Much was expected of the Suprematist black square.

In the early 1950s many of the manifestos and proclamations of the great Russian Suprematists and Constructivists were generally unknown (and inaccessible) in this country. But seminal writings of Kandinsky, Paul Klee and Mondrian were certainly in circulation, and the social and

political idealism of the great progenitors of Abstraction was a given. Frost was developing his own philosophy about the meaning of abstraction from those discussions with Heath and others, and later with Roger Hilton, whose ideas tended to the idiosyncratic and vehemently personal, but whose primary virtue was a fierce and uncompromising honesty. But at the beginning, in 1951, the optimistic year of the Festival of Britain, he was working as an assistant to Barbara Hepworth on a major sculpture for the Festival. 'It was a period', Frost recalls, 'when art and social commitment came together.' For some this indicated the necessity for social realism in art, but for many of Frost's closest artistic companions it was abstraction that provided the new language for the modern age.

It was a period, too, of transitional personal crisis for Frost, brought on by self-doubt and uncertainty of direction, and exacerbated by his sense that his painting – and painting as such – was still somehow *unreal*. 'It stopped me painting for a bit.

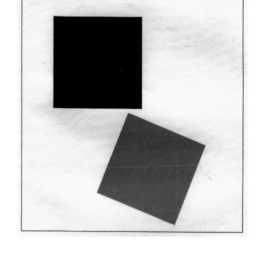

El Lissitzky from *About Two Squares*
construction 1 ('Here are two squares')

Here I was making something actual at Barbara's – and my painting seemed to rely, not on the actual, but on illusion. So I started making constructions and mobiles.' In this respect his personal response interestingly paralleled that of many of the great Russians he came so greatly to admire. Following Vladimir Tatlin, they too had opted for the 'material reality' of constructions against the inescapable pictorialism of painting, even Suprematist painting. Thus it was that Frost's admiration, even reverence, for the revolutionary painters of that earlier generation was grounded in deeply personal creative experience.

Frost recovered his footing. The revelation of the power of the graphic mark to effect a change of consciousness released him creatively. One can imagine the quickness of his intellectual and moral response to the statement made that same year of 1951 by his friend and erstwhile teacher Kenneth Martin, whose commitment to what he termed 'constructive or concrete' art was to remain coherently principled:

> The square, the circle, the triangle etc. are primary elements in the vocabulary of forms, not ends in themselves… Proportion and analogy is the base of such a pictorial architecture. The painting grows according to these laws and these have their counterpart in the laws of nature. Not painting which imitates the illusory and transient aspects of nature, but which copies nature in the laws of its activities…. [The painter] attempts to create a universal language as against a private language…. Heroic efforts have been made towards the creation of this language.

By the time of his inclusion in Alloway's *Nine Abstract Artists,* therefore, Frost was painting in the full consciousness of the heroic nature of his vocation, and with a developed historical awareness of the idealism of his greatest predecessors.

And at that very moment Frost was moving towards the most rigorous realisations in painting of the fundamental principles of his own art. In 1954 he took up his post as Gregory Fellow at Leeds. There he was to work closely with Harry Thubron, Tom Hudson and others, including Herbert Read and Victor Pasmore, on the development of a modern 'basic course' in art, architecture and design. The Bauhaus is usually cited as the model for this experiment, but concrete information about the work of that great pioneering institution was scarce in the mid-1950s, and

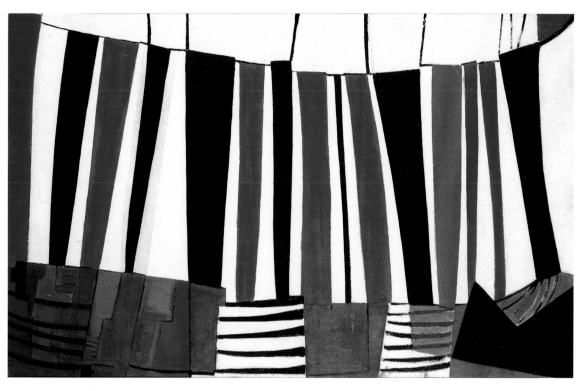

Terry Frost *Red, Black and White, Leeds* (1955) oil on board 1220 x 1828 mm © the artist private collection

it is more likely that the ideas of Klee and Kandinsky (ideas developed at the Bauhaus in the early 1920s) were a major inspiration. Read had personally introduced the translation of Klee's *On Modern Art* in 1948, and the *Pedagogical Sketchbook*, translated and introduced by Sybil Moholy-Nagy, had aroused much interest among artist-teachers on its publication in 1953. Kandinsky's pedagogical *Point and Line to Plane* had been published in English in 1947. Frost was once more a participant in disciplined discussions of constructive problems of art and design, in which there was constant reference to the fundamental principles of modernism.

The paintings of the mid to late 1950s – the paintings of Frost's Leeds years – were far from being simply 'abstractions' that were 'drawn *out of* or *away from*' aspects of observed nature. They convey a complex compound of perception and inner response, of seeing, feeling and being that went far beyond the representation of what he had described in 1954 as 'a state of delight in front of nature'. Frost had, from the very beginning, developed an inventory of concrete signs and motifs which could be deployed in an infinite variety of vital configurations and relationships. His paintings are events for the eye, formal realities of their own, in which those recurrent motifs, drawn from the lexicons of both Euclidean and projective geometries, are disposed in thrilling dynamic interactions. Discs and half-discs, chevrons and arrows, triangles and quarter-circle segments, looping lines, rod-like verticals, single strokes and scattered dots, lozenges, spirals, C-shapes and D-shapes: these simple elements are in a constant play of sway and swing, spin and spiral, turn and balance, tumble and hold. 'I am not copying nature', he declared, 'but endeavouring to construct my paintings in the same way as nature, so that they have a trueness about them and a reality as big as nature.'

Frost's bravura deployment of these familiar visual devices within the rectangle of the canvas, their combinations and re-combinations, their repetitions and rhymes, echoes and reversals, proximities and distances, equilibriums and imbalances are as infinitely various as are those relations of objects in the natural world to which they obliquely and ambiguously refer. They are as formally conventional and sign-like as Lissitzky's Cs and the graphic characters of his suite of prints for *Victory over the Sun*, or Malevich's squares, discs and triangles. They occupy, like those Suprematist figures, an imagined space that is neither purely two-dimensional nor illusionistically three-dimensional. It is the invented, or implied, space of the fourth dimension, in which time and space coalesce, and whose inhabitant forms can only find representation in simplified sign and symbol. His paintings are thus to be seen as symbolic analogies of actual experience, representations of being in the world of objects, light and movement.

Frost's 'installation around an idea' is to be seen, then, before anything else, as an act of homage to the great Russian progenitors of modernist abstraction, as a creative celebration of the Suprematist and Constructivist belief in art as an agency for the liberation of the human spirit. 'It is based on the vision of the Russian revolutionary painters', he said to the present writer recently, 'at a time when the revolution seemed to them to have total integrity, and before the

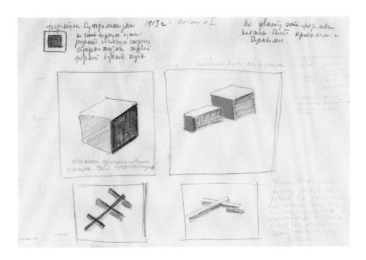

Malevich *Table no. 1. Formula of Suprematism* (1913?)
paper/watercolour and graphite pencil 36 x 54
© The State Russian Museum

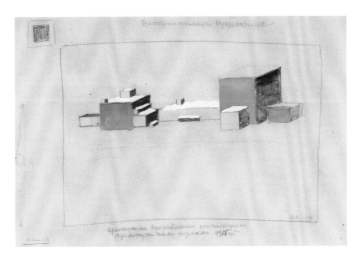

Malevich *Table no. 3. Spatial Suprematism* (1916?)
paper/watercolour, egg white and graphite pencil 36 x 54.1
© The State Russian Museum

politicians moved in to ruin it completely. I believe in that belief in something! They had an idea, and it is a true idea.' It was of course the idea that art is a revelation of the reality beyond the immediately visible and tangible, a reality accessible, by means of intuitive procedures and symbolic devices, to the active imagination. Frost did not have to adopt the metaphysics of Malevich or the proselytising fervour of Lissitzky to understand as an artist the claims that they and others, such as Alexander Rodchenko and Tatlin, had made for constructive art.

Frost, is natively predisposed to the rational and the democratic. He has been continuously inspired by the Constructivist insights that visual simplicity is a means to the communication of complex ideas and experiences, that art can be made of everyday things (in terms of materials and of subject matter) and, above all, that art can enter *and transform* ordinary life in many different ways. 'The Russians', he once exclaimed, 'El Lissitzky ... Rodchenko, they are my gods. It's the discipline of the work that affects me.' At last, in this installation, limiting himself to the primary colours of Russian revolutionary art – black, white and red – the colours of matter and space, and of hope in the future, Frost has made his own manifesto, at once looking backwards and forwards. Those colours have long been a favourite combination for other, more formal reasons. They are valued for the dynamic of their equality of weight and presence on the surface, their tendency when placed together to create ambiguities of spatial relation, and to flatly contradict distinctions of figure and ground.

As early as 1915 Malevich began to project the development of suprematist forms from their basic two-dimensional representation in drawing and painting to their architectural realisation in three dimensions. In a carefully ordered sheet of drawings, identified as *Table no.1*, beside a small diagram of the original *Black Suprematist Square* of 1914–15, he wrote: 'Formula of Suprematism 1913. It is essential to develop the volumetric aspect of Suprematism according to this formula. The first form will be the cube. To the right of this inscription he wrote: 'In colour these forms should be red and black.' Beneath are four schematic drawings, each within its own demarcated rectangle. The first is of a cube, indicated as black by shading on two of the visible faces; the second is of a cube next to a smaller oblong, each of whose visible faces are black, white and red. The third (at lower left) is of a three-dimensional figure, seen as from above, that Malevich describes in a caption as an 'elongated cube', in which a central black and white bar is intersected at right angles by three red and black cross bars. The fourth, is of two adjacent forms,

one of two intersecting rectangular blocks, the other a simple oblong, which are drawn as if they were low-lying buildings seen at a distance from slightly raised ground.

There is a further pedagogic sheet, dated 1916, clearly intended to belong with the first (it has the diagrammatic black square in the same top left position) and numbered as *Table no.3* (*No.2* seems to have been lost). It presents us with a much more ambitious development. It is an attenuated configuration of abutting cubes and oblong forms that suggests, or proposes, a modernist building of strictly orthogonal cubic components. It is captioned: 'architecton: horizontal rendered more complex by intermediate forms.' These early projections of the spiritually energetic two-dimensional forms of Suprematism into the everyday three-dimensional world are clearly intended to generate an architecture that is imaginative and transformative. '[In] this way', Malevich wrote on the first sheet, 'we can arrive at a new type of architecture, a pure type outside of any practical aims, because architecture begins where there are no practical aims. Architecture as such.' It is architecture as a proposal of spiritual possibilities, architecture as a three-dimensional geometry of the spirit. In his remarkable and spectacular installation Frost has made these projections objective, tangible and spatial, taking his own step into the space between dimensions and inviting us to follow him into a new world of imaginative possibilities. It is a marvellous climactic affirmation of a long-held belief in the meaning and power of Art.

MEL GOODING

JANUARY 2003

NOTES AND REFERENCES Unless otherwise indicated all quotations from Terry Frost are from conversations with the author in December 2002, or from *Terry Frost*, ed. Elisabeth Knowles, Aldershot, 1994. For writings by Patrick Heron, see *Painter as Critic: Patrick Heron: Selected Writings,* ed. Mel Gooding, London, 1998. Lawrence Alloway is quoted from his *Nine Abstract Artists: their work and theory* (with statements from the artists), London, 1954 (p12). (Frost's remark about his painting as an expression of 'a state of delight in front of nature' is from the text he contributed to this volume.) William Townsend reports Pasmore's remarks about art and nature in *The Townsend Journals*, ed. Andrew Forge, London, 1976 (p77). For relevant material on Malevich and Lissitzky see *On Suprematism 34 Drawings*, and *More about Two Squares*, Forest Row, Sussex, 1990. The latter reprints Lissitzky's 1920 UNOVIS manifesto *suprematism in world construction*, from which Lissitzky is quoted. Kenneth Martin is quoted from *Broadsheet No 1*, a pamphlet published to accompany the exhibition 'Abstract Art' at the AIA Gallery, London, in 1951.

pp 21– 44 (see also pp 2, 7)

INSTALLATION **CONTRASTS IN RED, BLACK AND WHITE**

2002/03 acrylic on canvas

25 parts each 762 x 762 mm 1 part 2286 x 2286 mm (opposite)

© the artist collection the artist

p 5 work in progress in the artist's studio

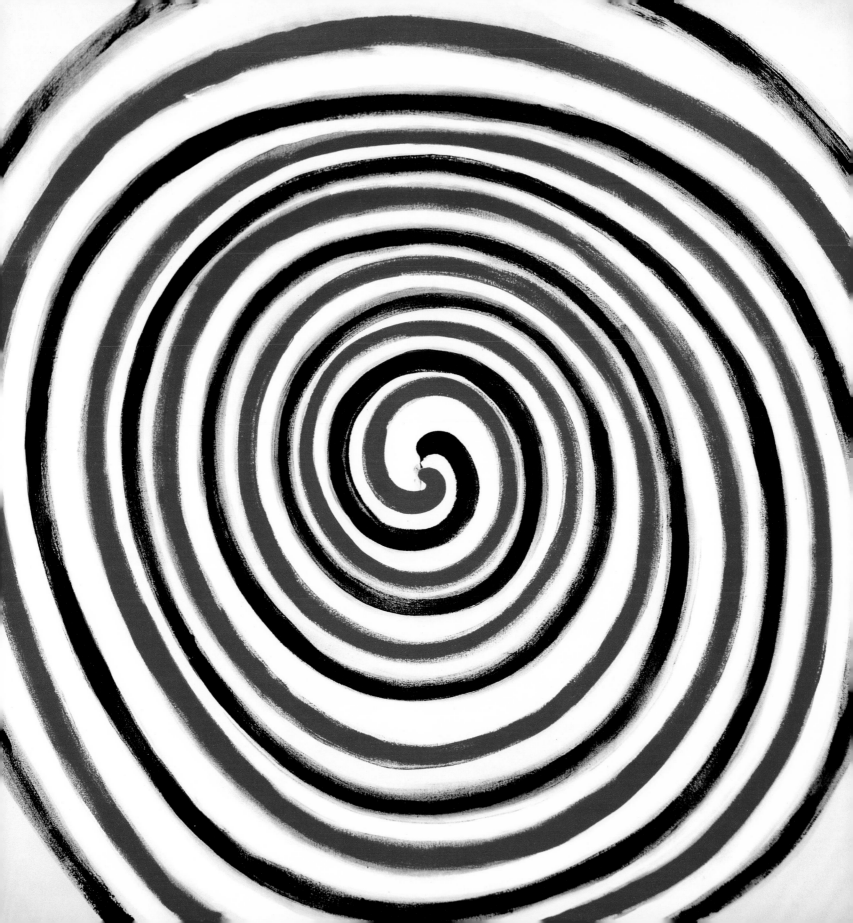

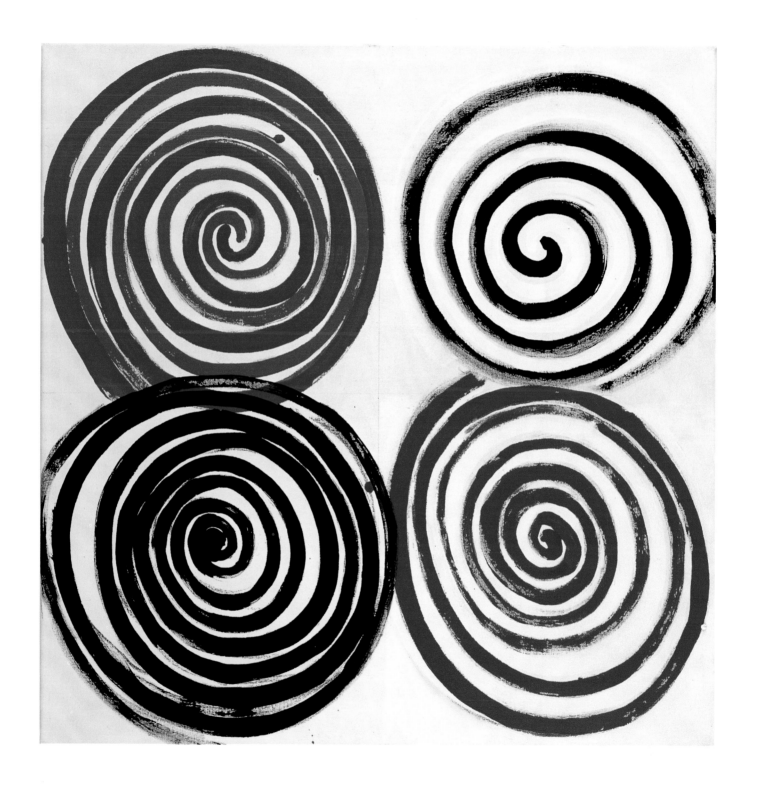

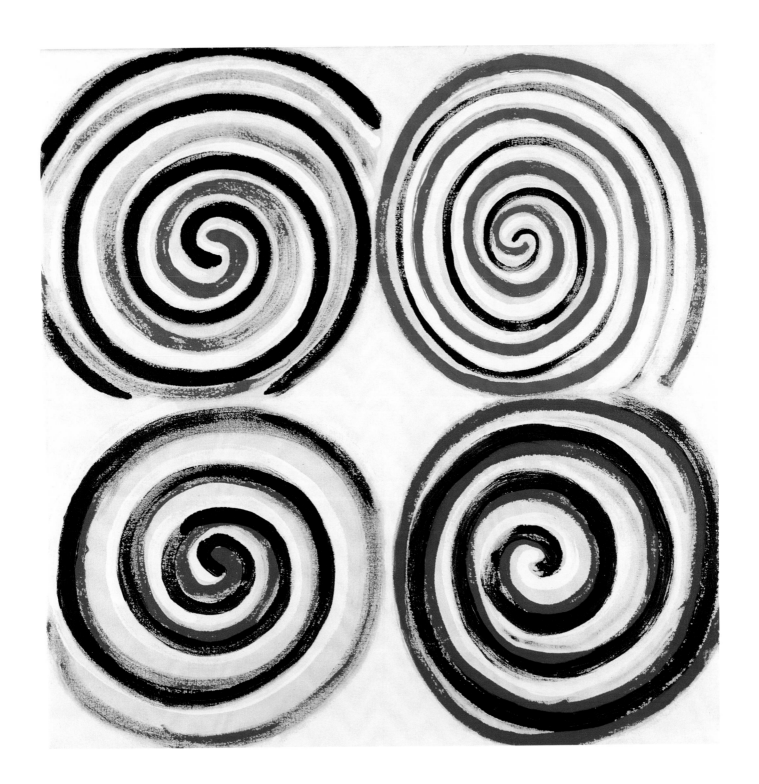

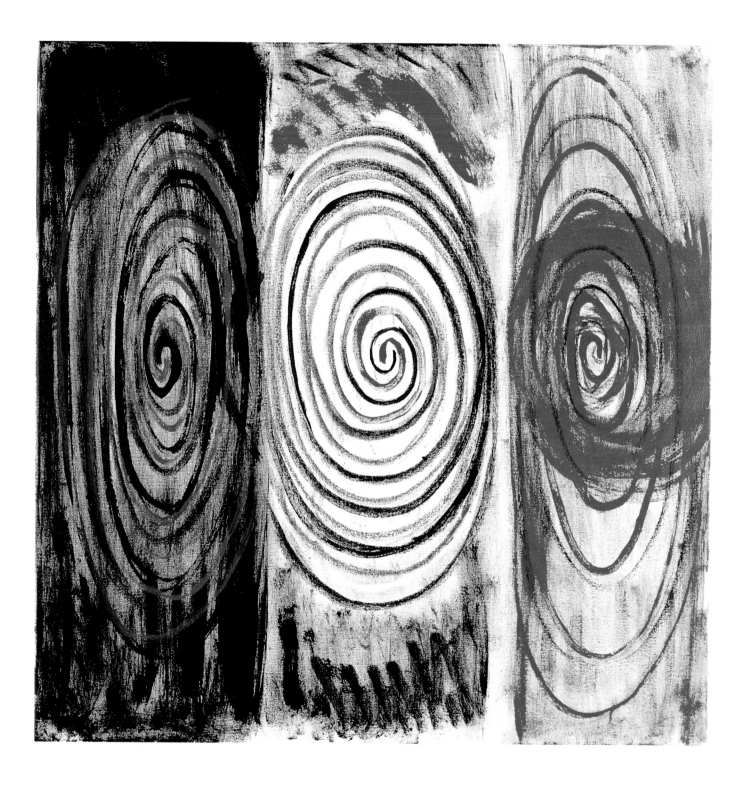

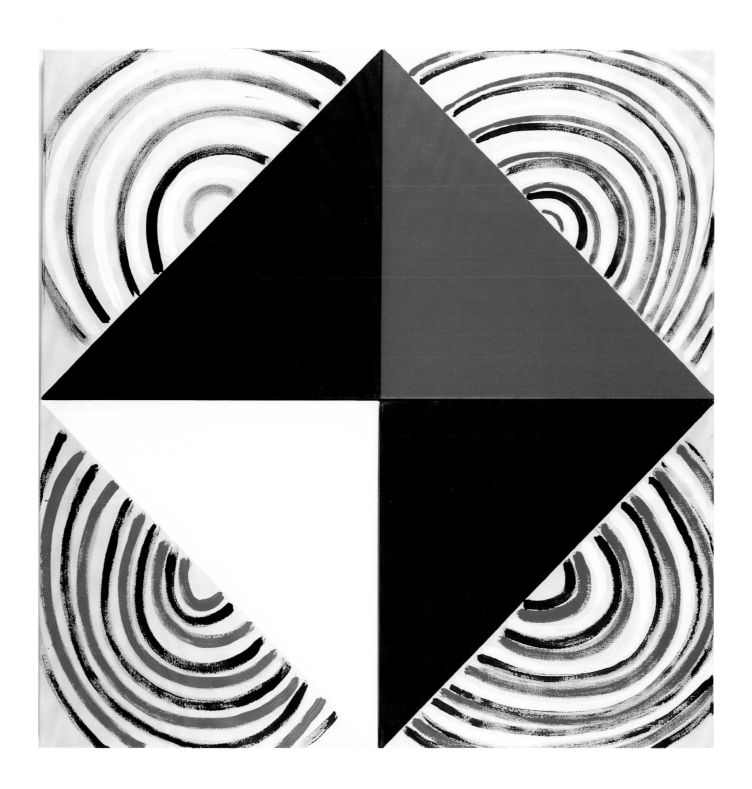

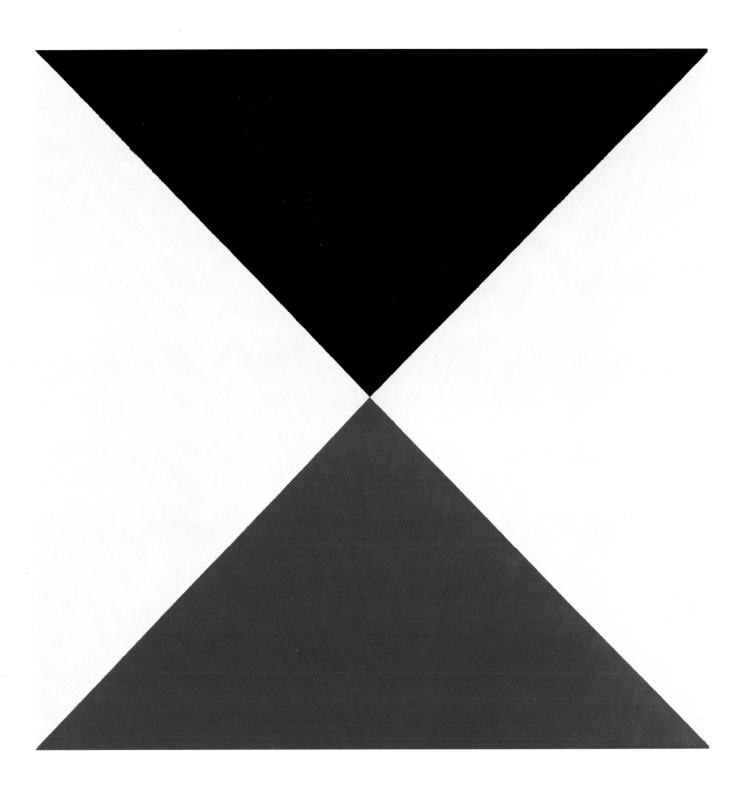

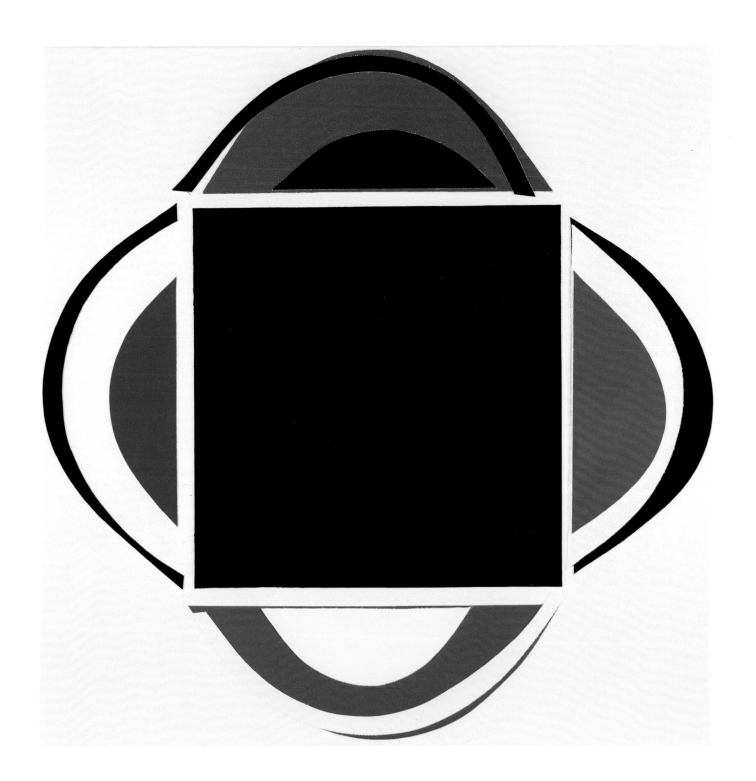

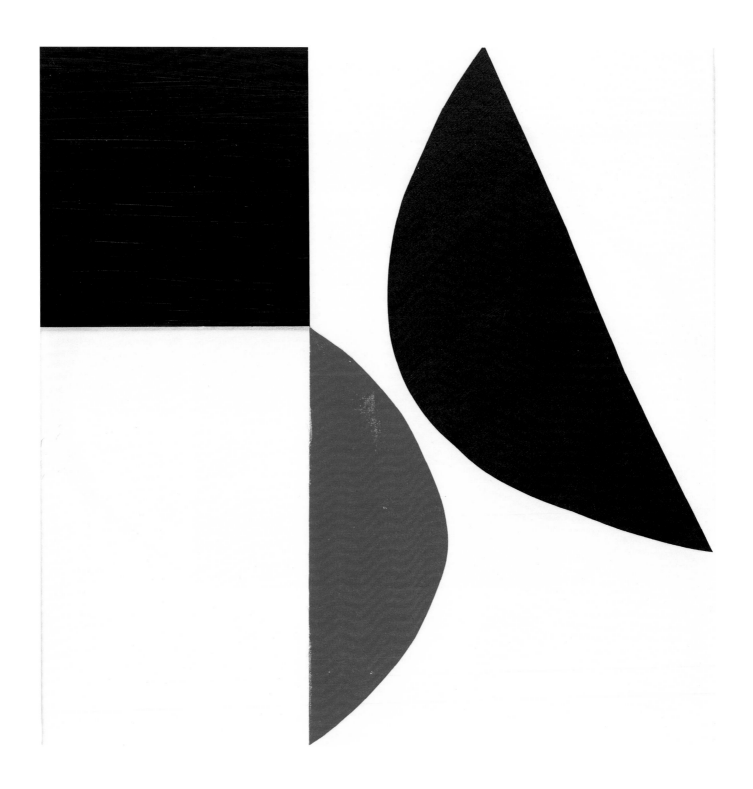

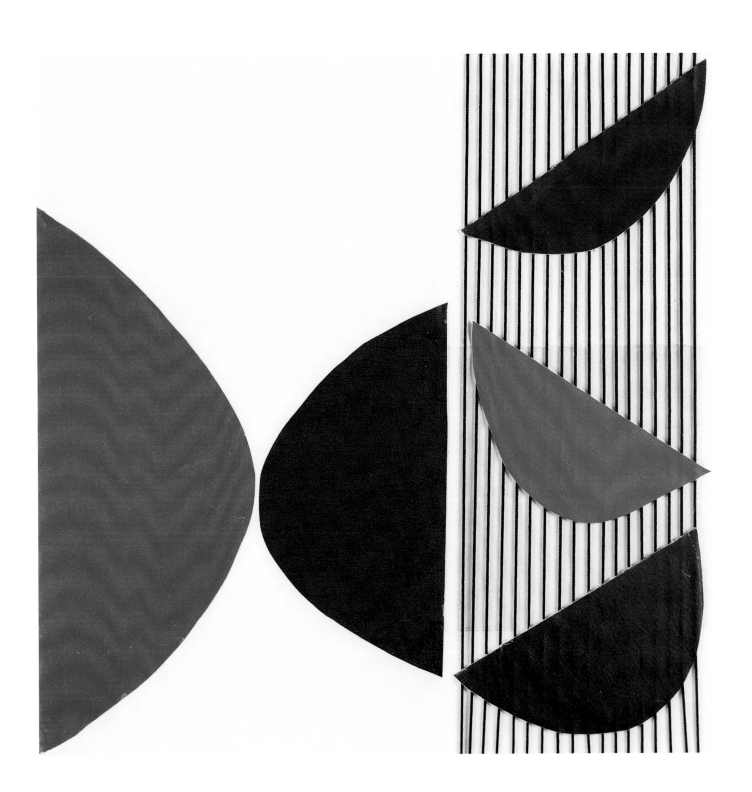

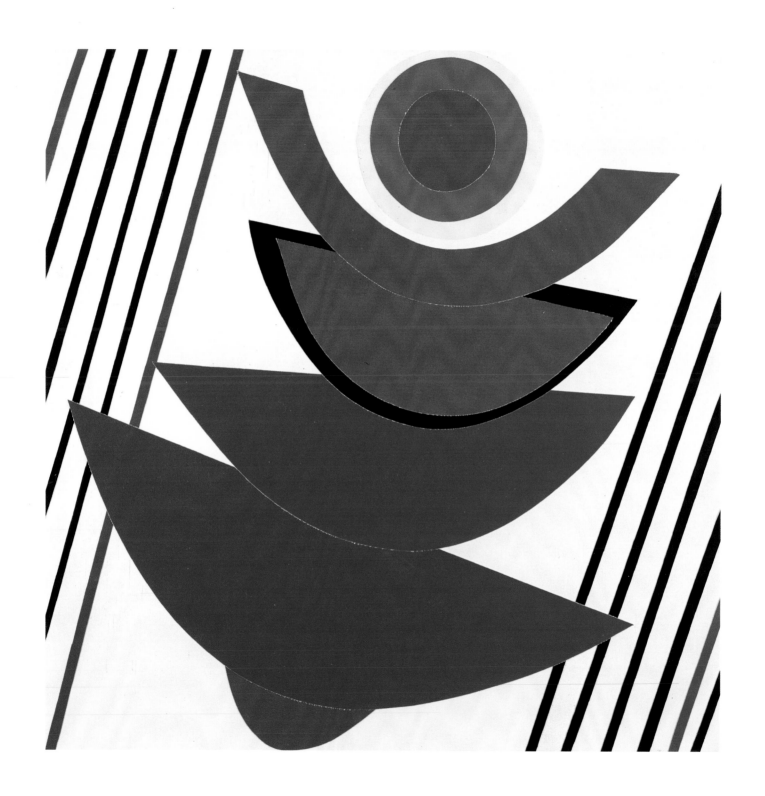

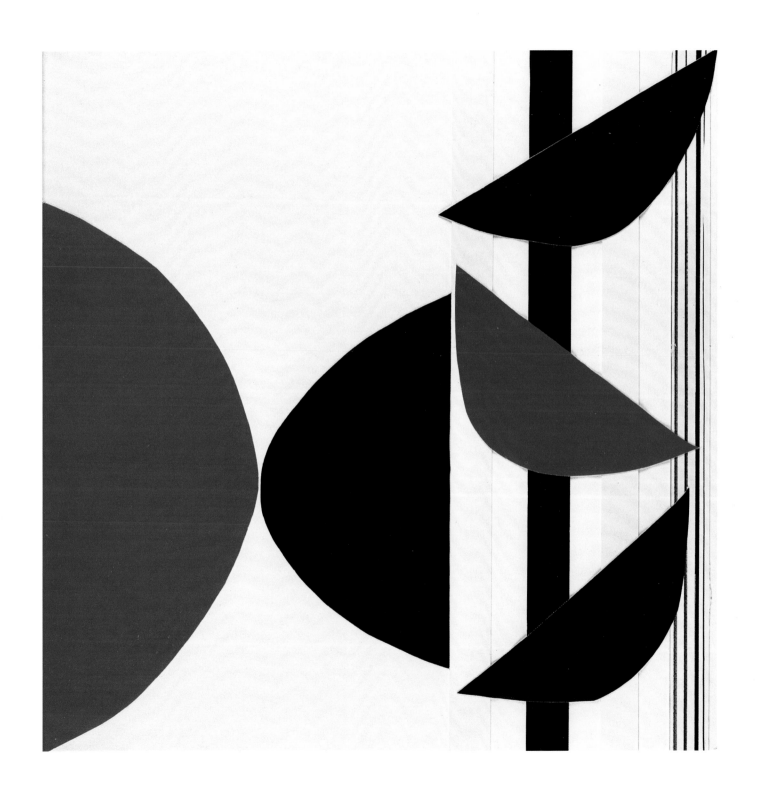

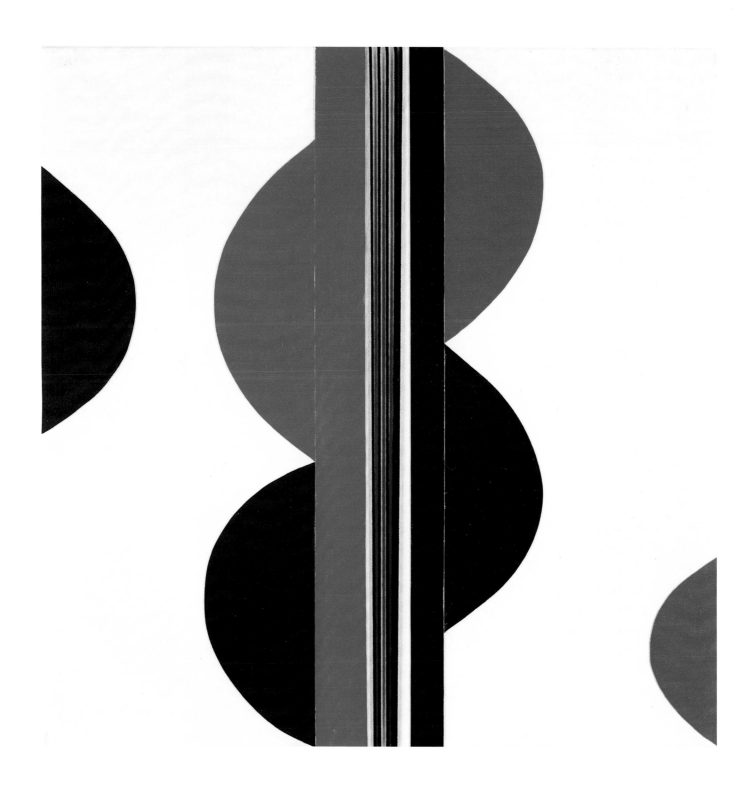

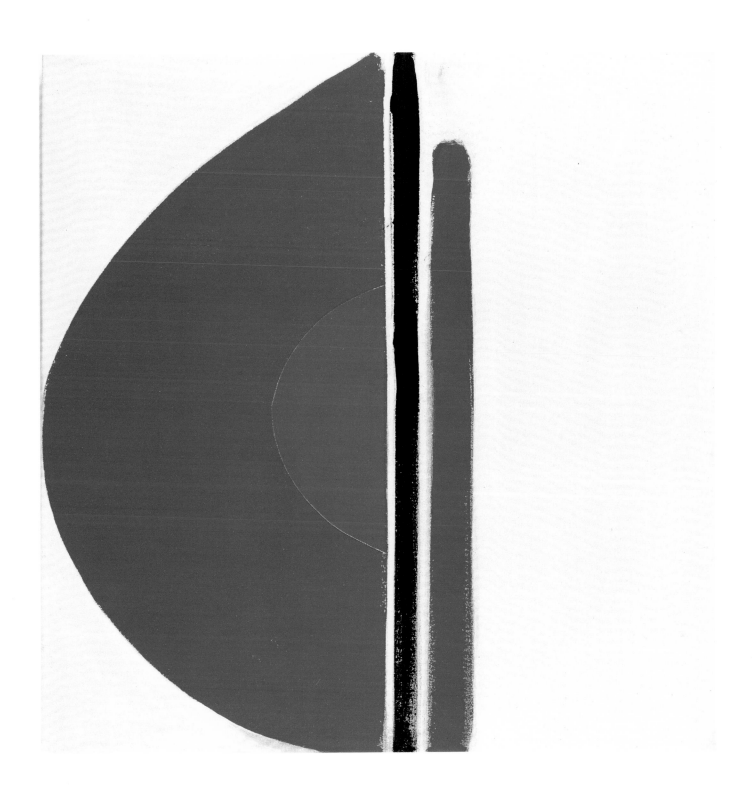

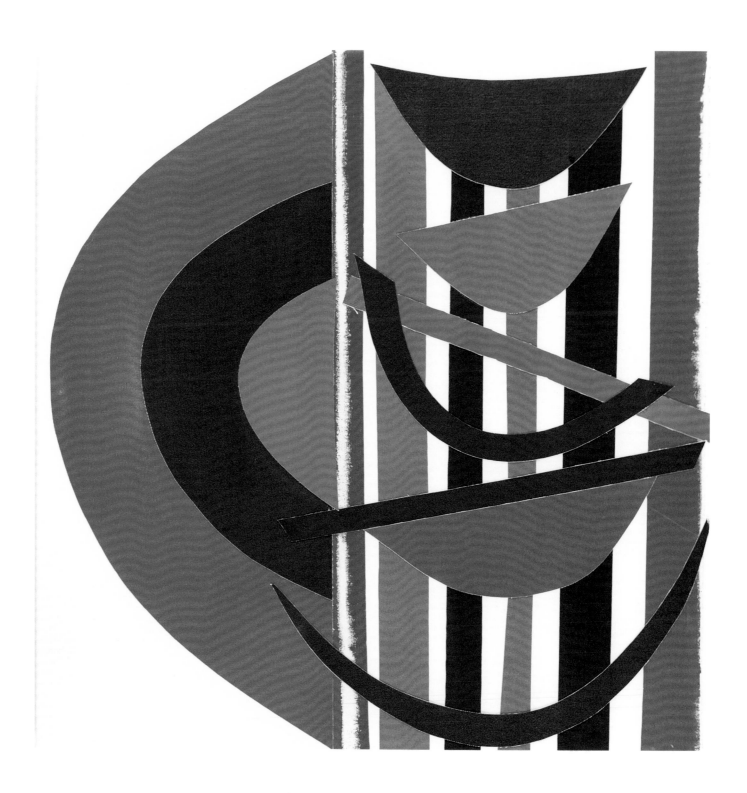

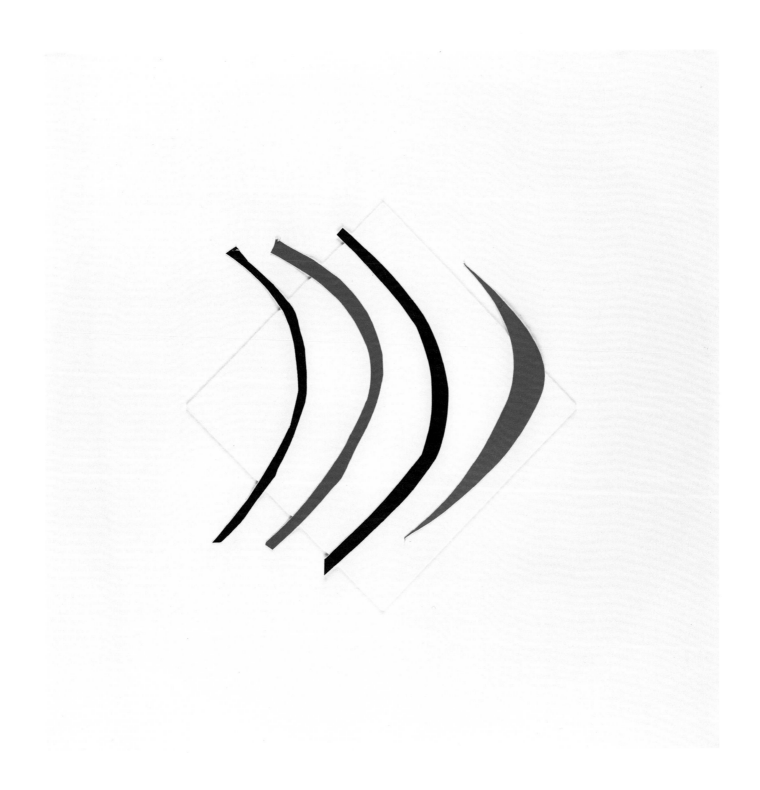

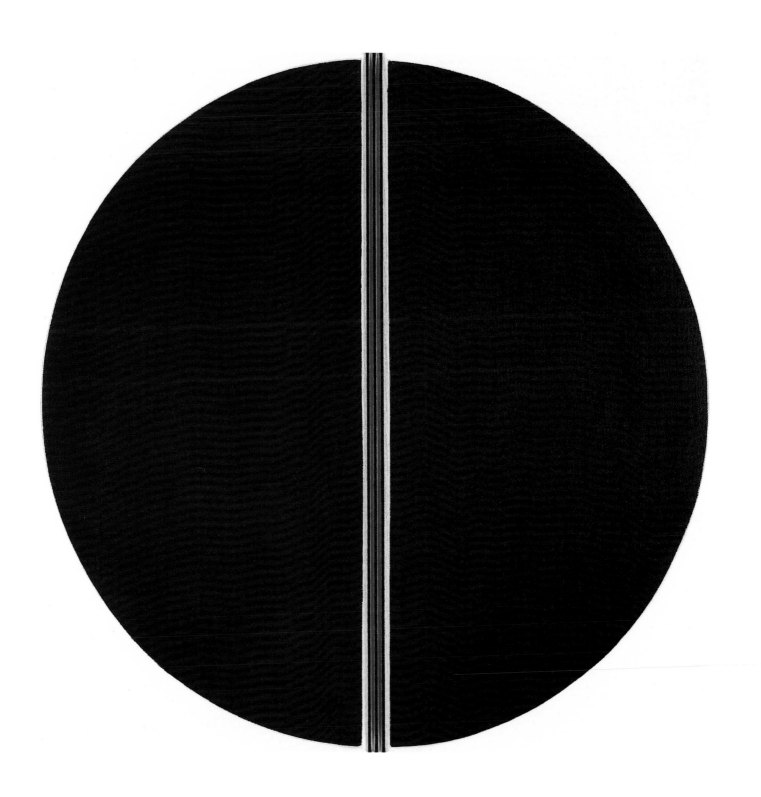

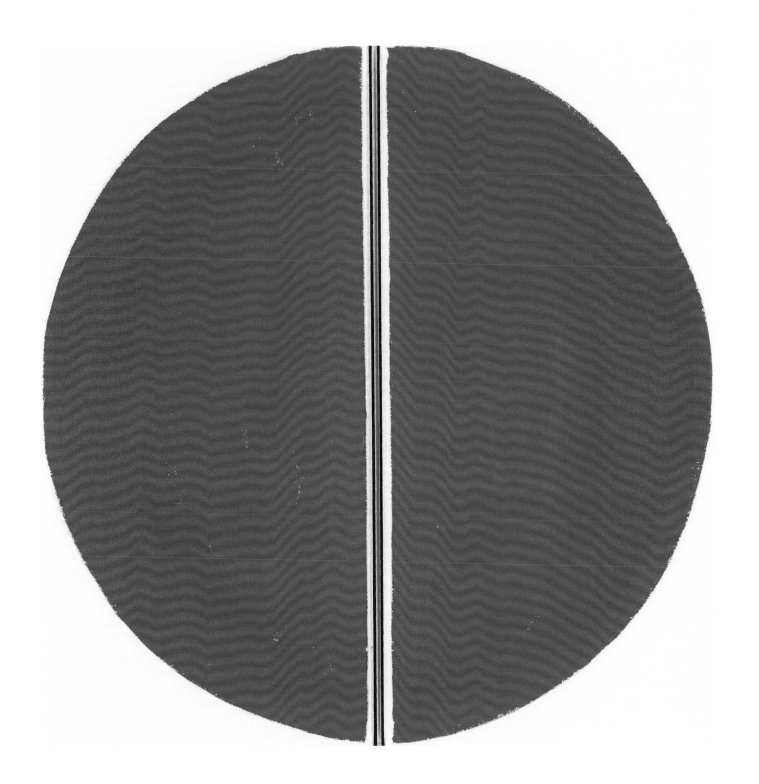

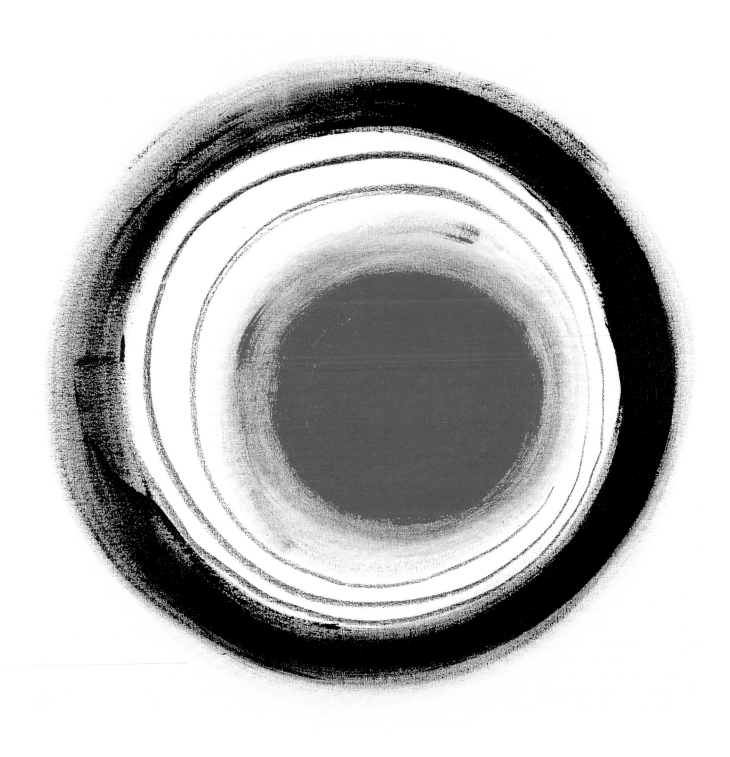

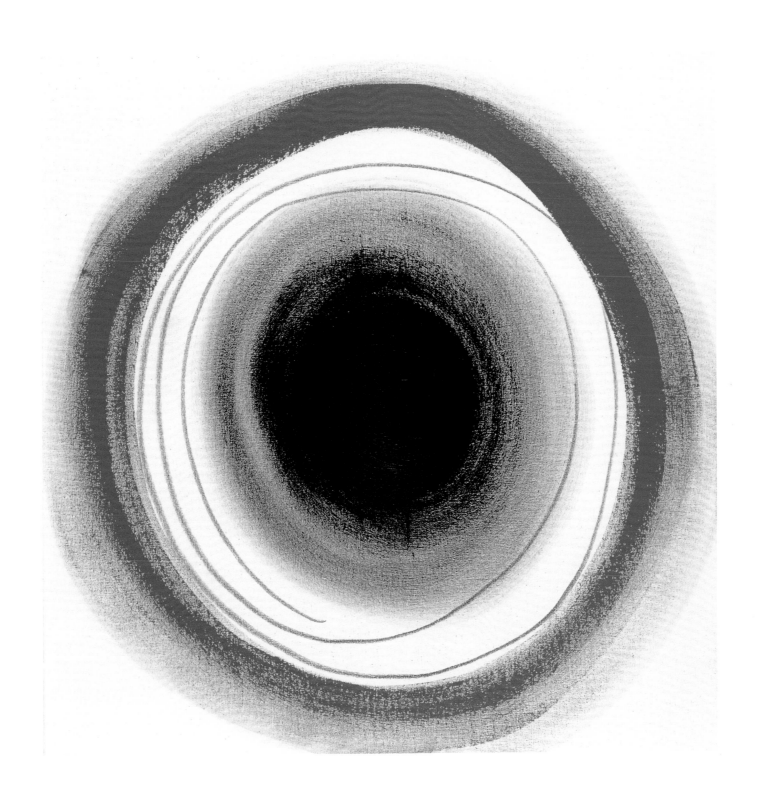

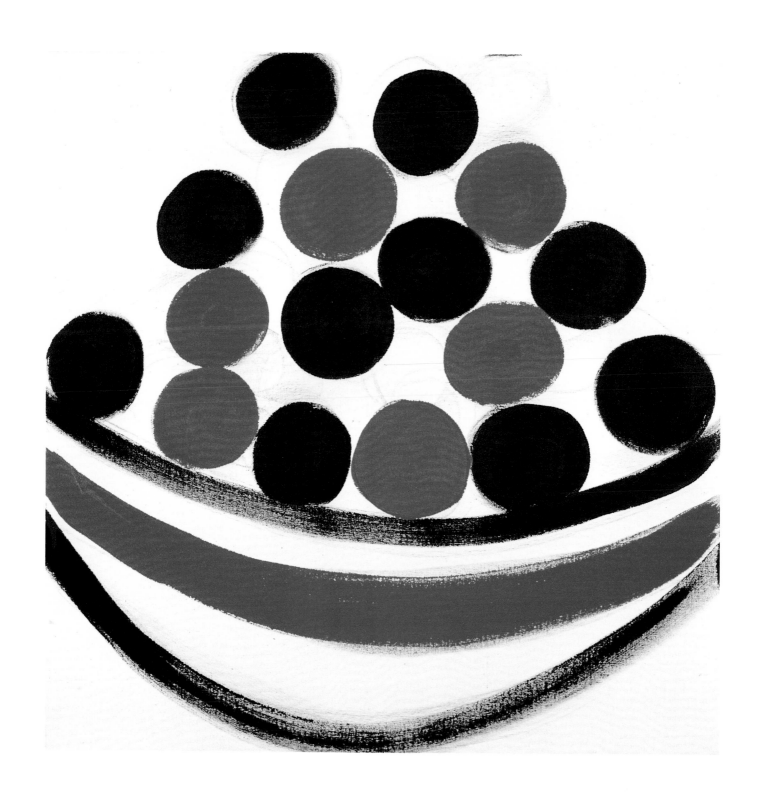

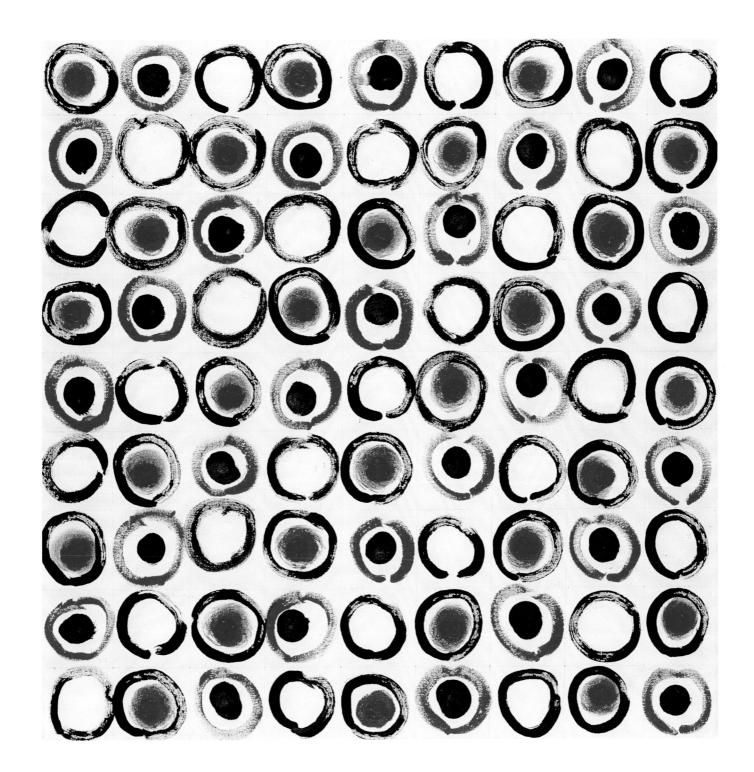

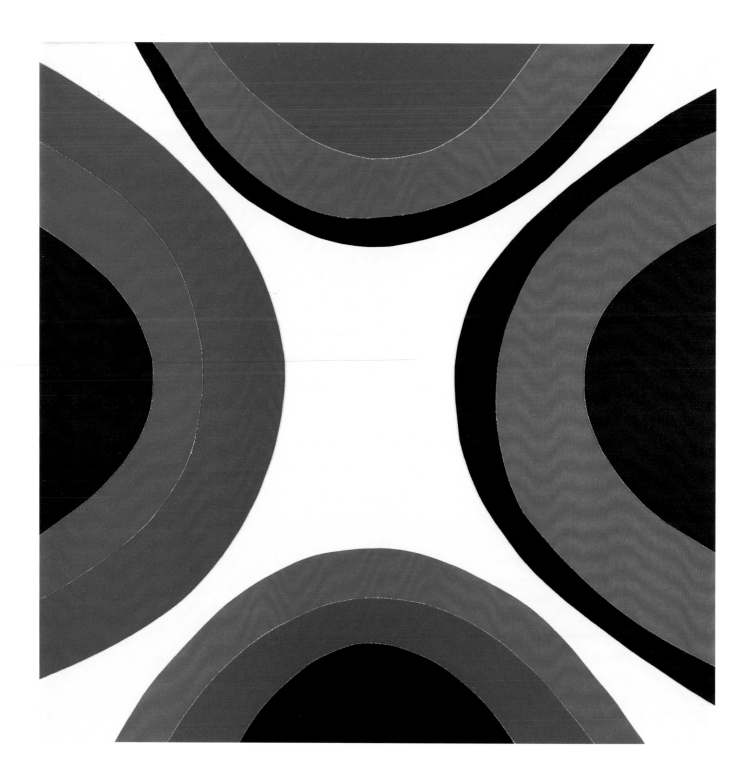

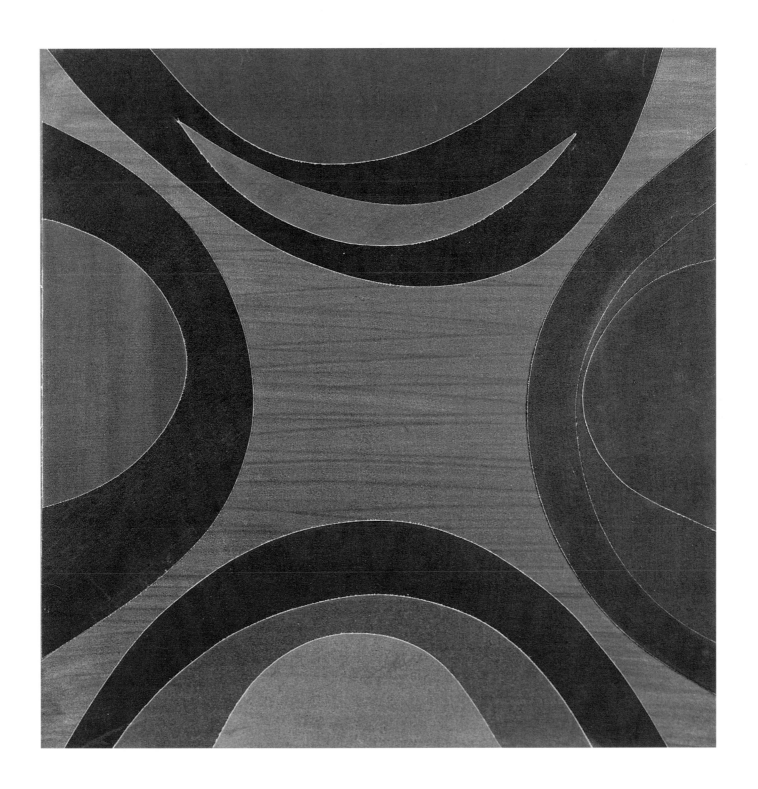

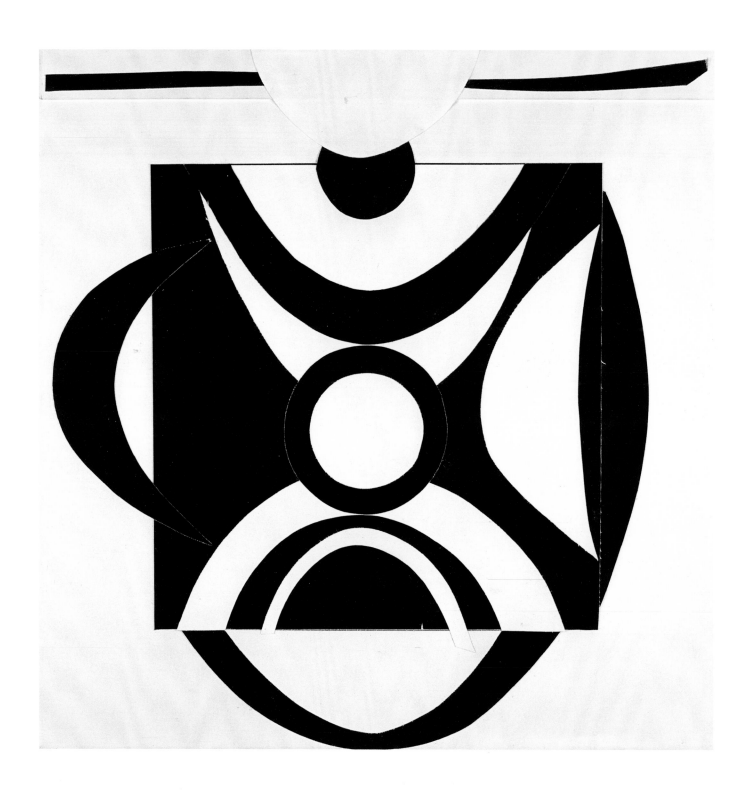

TERRY FROST

	British Art Today, San Francisco Museum of Art and tour	1986	Looking West, Newlyn Art Gallery and Royal College of Art
1963	British Painting in the Sixties, CAS at the Tate and Whitechapel Galleries	1989	The Presence of Painting, South Bank Centre
	John Moores Liverpool 4, Walker Art Gallery	1993	Royal Academy Summer Exhibition
1964	Contemporary British Painting and Sculpture, Albright-Knox Art Gallery, Buffalo	1994	Here and Now, Serpentine Gallery
	1954–1964: Painting and Sculpture of a Decade, Gulbenkian Foundation Collection, Tate Gallery	1995	McGeary Gallery, Brussels Flowers East, London Newlyn Art Gallery
	New Painting, 1961–64, Arts Council Tour	2000	Summer 2000, Beaux Arts, London
1965	John Moores 5, Walker Art Gallery	2002	Square Root, Sarah Myerscough Fine Art, London
	Frost, Heron, Hilton, Wynter, Waddington Galleries		In Print, Contemporary British Art from the Paragon Press, worldwide touring exhibition

	British Art Today, San Francisco Museum of Art and tour
1963	British Painting in the Sixties, CAS at the Tate and Whitechapel Galleries
	John Moores Liverpool 4, Walker Art Gallery
1964	Contemporary British Painting and Sculpture, Albright-Knox Art Gallery, Buffalo
	1954–1964: Painting and Sculpture of a Decade, Gulbenkian Foundation Collection, Tate Gallery
	New Painting, 1961–64, Arts Council Tour
1965	John Moores 5, Walker Art Gallery
	Frost, Heron, Hilton, Wynter, Waddington Galleries
	Peter Stuyvesant Foundation collection purchases, Whitechapel Gallery
1966	Blow, Frink & Frost, Prestons Art Gallery, Bolton
	3rd Open Painting Exhibition, Ulster Museum, Belfast
1967	Recent British Painting, Stuyvesant Collection exhibition, Tate Gallery
1968	British Art Today, Hamburg Kunstverein
1969	John Moores Liverpool 7, Walker Art Gallery
1970	British Painting 1960 – 1970, National Gallery of Art, Washington
1974	British Painting 1974, Arts Council, Hayward Gallery
1977	British Painting 1952 – 1977, Royal Academy
	Pier Arts Centre exhibition, Tate Gallery
	Cyprus Summer School staff exhibition, Gallery Zygos, Nicosia
1980	Hayward Annual, Arts Council, Hayward Gallery
	Pictures for an Exhibition, Whitechapel Gallery
1984	Landscape in Britain, Arts Council, Hayward Gallery
	English Contrast, Art Curial, Paris
	Frost, Paraskos, Charalambides, Gloria Gallery, Nicosia
1985	St Ives 1939 – 1964, Tate Gallery

1986	Looking West, Newlyn Art Gallery and Royal College of Art
1989	The Presence of Painting, South Bank Centre
1993	Royal Academy Summer Exhibition
1994	Here and Now, Serpentine Gallery
1995	McGeary Gallery, Brussels
	Flowers East, London
	Newlyn Art Gallery
2000	Summer 2000, Beaux Arts, London
2002	Square Root, Sarah Myerscough Fine Art, London
	In Print, Contemporary British Art from the Paragon Press, worldwide touring exhibition

APPOINTMENTS & FURTHER ACHIEVEMENTS

1951	Worked as an assistant to Barbara Hepworth
1952–54	Taught at Bath Academy of Art
1954–56	Gregory Fellowship in Painting at Leeds University
1964	Lecturer at Reading University
1964–65	Fellow in Fine Art, University of Newcastle
1977	Professor of Painting, University of Reading
	The Hon Degree of Doctor of Laws awarded by the CNAA
1981	Retired from Reading and made Professor Emeritus
1989	Lectured at Hyogo Prefectural Museum of Modern Art, Kobe City, Japan
1997	Installation of works in The European Commission Conference Centre, Albert Borscette Building, Brussels
	Commissioned by British Airways as a designer of their new plane tail logos
1998	Knighted in the New Years Honours list
	The Hon Degree of Doctorate of Arts awarded by University of Plymouth
1999	The Hon Degree of Letters Awarded by University of Exeter
2000	The Hon Degree of Doctor of Letters awarded by University of Warwick

PUBLISHED TO ACCOMPANY THE EXHIBITION AT TATE ST IVES

8 February – 11 May 2003

ISBN 1 85437 478 8

A catalogue record for this publication is available from the British Library

© Tate Trustees 2003 all rights reserved

EDITORS Susan Daniel-McElroy and Matthew Gale

PHOTOGRAPHY Bob Berry DESIGN Groundwork, Skipton

REPRO Twenty Twenty Displays, Falmouth PRINT Triangle, Leeds